Celtic and Medieval Alphabets

Alphabets

53 Complete Fonts

Celtic and Medieval Alphabets

53 Complete Fonts

Selected and Arranged by

Dan X. Solo

from the
Solotype Typographers Catalog

DOVER PUBLICATIONS, INC.
Mineola, New York

Bibliographical Note

Celtic and Medieval Alphabets: 53 Complete Fonts is a new work, first published by Dover Publications, Inc., in 1998.

DOVER *Pictorial Archive* SERIES

Library of Congress Cataloging-in-Publication Data

Solo, Dan X.
 Celtic and medieval alphabets : 53 complete fonts / selected and arranged by Dan X. Solo from the Solotype Typographers catalog.
 p. cm. — (Dover pictorial archive series)
 ISBN-13: 978-0-486-40033-4 (pbk.)
 ISBN-10: 0-486-40033-6 (pbk.)
 1. Celtic type. 2. Medieval type. 3. Printing—Specimens. 4. Alphabets. I. Solotype Typographers. II. Title. III. Series.
Z250.5.C42S65 1998
686.2'24—dc21 97-35235
 CIP

Manufactured in the United States by Courier Corporation
40033605
www.doverpublications.com

A Note About the Types

The calligraphy of the medieval scribes served as models for the first printing types made in the fifteenth century. As other styles evolved in the years that followed, the early letterforms never completely lost their appeal. Many of the alphabets shown here are the work of nineteenth century typefounders paying homage to the scribes of old. In a few of these fonts, the letter I serves also as the letter J. Decorative initial sets often omit the X and Z, which are seldom used at the beginning of a sentence.

Anglo Text

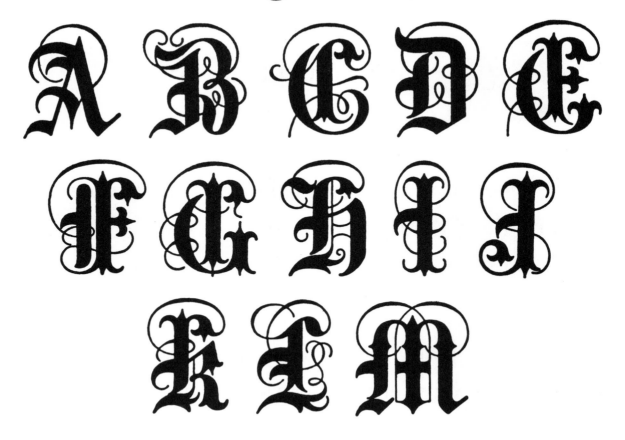

abcdefghijklmn

Anglo Text

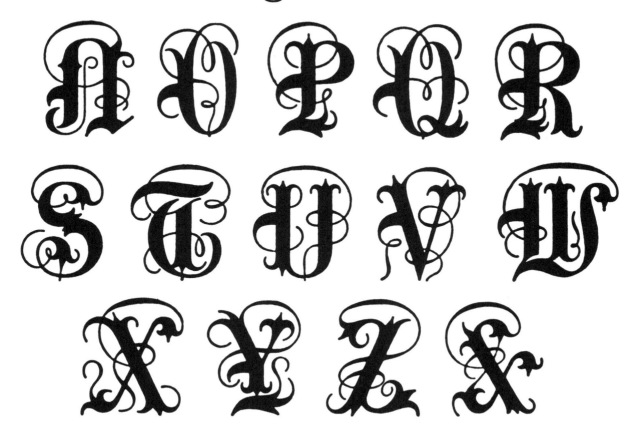

opqrstuvwxyz

Camden Text

A B C D E
F G H I J
K L M
a b c d e f g
h i j k l m

4

Camden Text

NOPQR
STUVW
XYZ
nopqrst
uvwxyz

Chappel Text

ABCDE

FGHIJK

LMM

abcdefghij

klmnopqr

Chappel Text

NOPQR
STUVW
XYZ

sʃtuvwxyʒ

1234567890

Cimbrian

A B C D E

F G H I J

K L M N

a b c d e f g

h i j k l m

8

Cimbrian

O P Q R S

T U V W

X Y Z

n o p q r s t u

o w x y z

ColchesterBlack

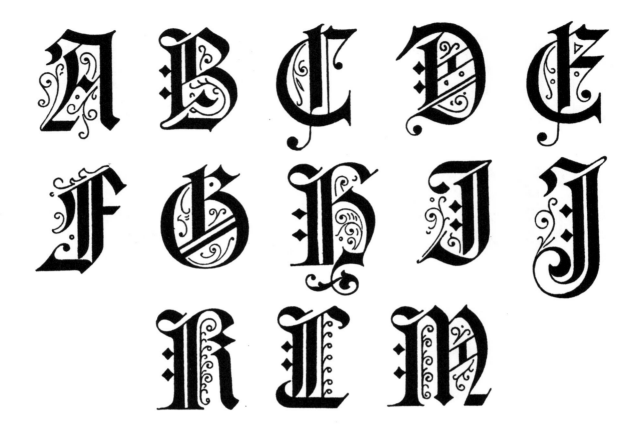

Colchester Black

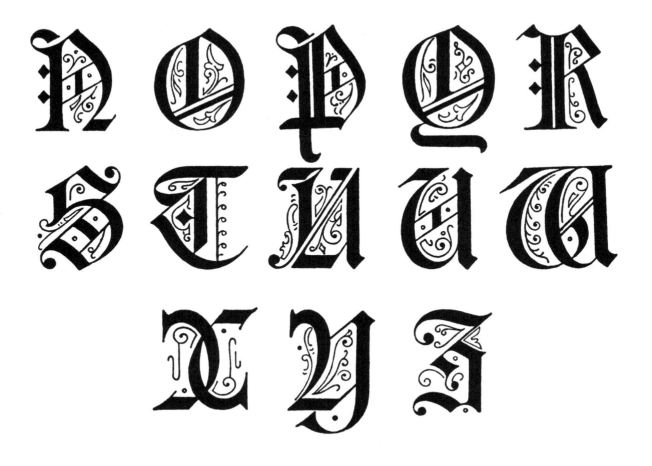

r s t u v w x y z

1 2 3 4 5 6 7 8 9 0

Devon

ABCDE

FGHIJ

KLM

abcdefgh

ijklm

Devon

NOPQR
STUVW
XYZ

nopqrstu
vwxyz

Devonian

ABCDE
FGHIJ
KLM

abcdefgh
ijklmnopqrs

14

Devonian

NOPQR
STUVW
XYZ

tuvwxyz

1234567890

Durer Gothic Condensed

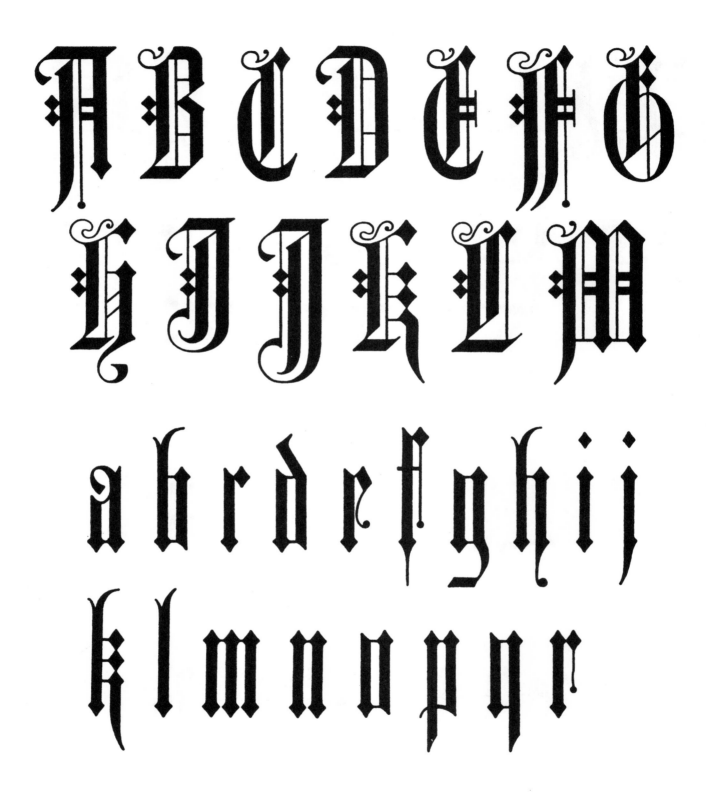

Durer Gothic Condensed

N O O P Q R S T

U U W X Y Z

s t u v w x y z

1 2 3 4 5 6 7 8 9 0

Durwent

ABCD
EFGHI
JKLM

abcdefg
hijklmn

Durwent

NOPQ
RSTUV
WFYZ

opqrstu
vwfyz

Fenwick

ABCDEF

GHIJK

LM

abcdefghijklm

12345

Fenwick

NOPQRS

TUVW

XYZ

nopqrstuvwxyz

67890

Genzsch Initials

Genzsch Initials

Gloucester Initials

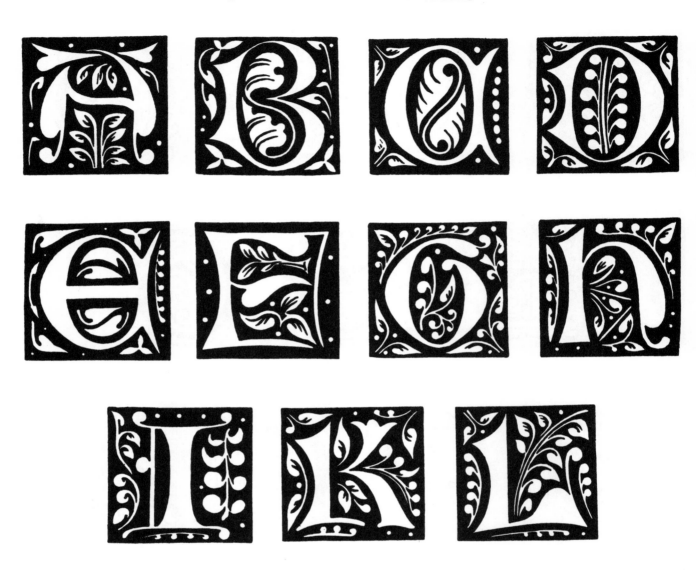

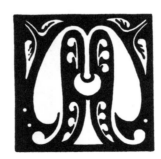

Gloucester Initials

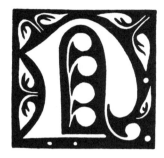 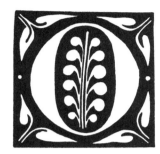

Grafik Text

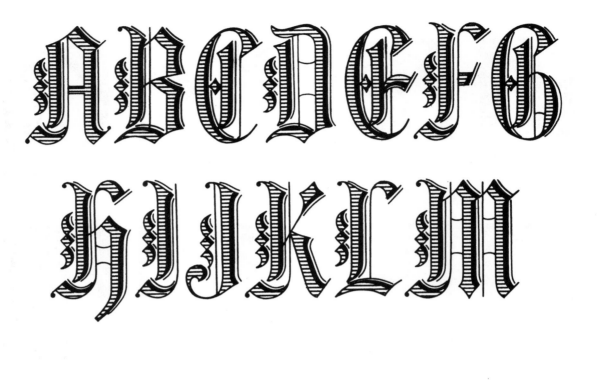

Grafik Text

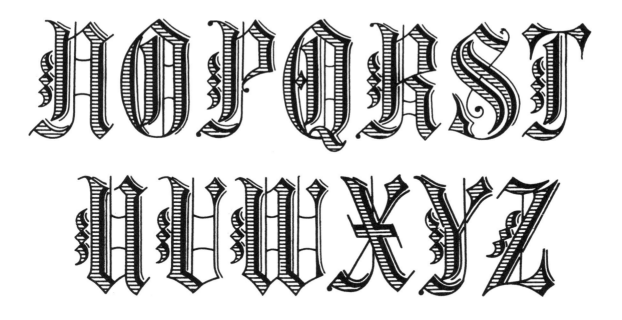

N O P Q R S T
U V W X Y Z

o p q r s t u v w x y z

6 7 8 9 0

Guildhall

A B C D

E F G H I

J K L M

a b c d e f g h i j

k l m n o p q r

Guildhall

N O P Q

R S T U V

W X Y Z

s t u v w x y z

1 2 3 4 5 6 7 8 9 0

Gutenberg Gothic

ABCDE

FGHII

KLM

abcdefghi

jklmnopqr

Gutenberg Gothic

NOPQR
STUVW
XYZ

stuvwxyz
1234567890

Hamburg Initials

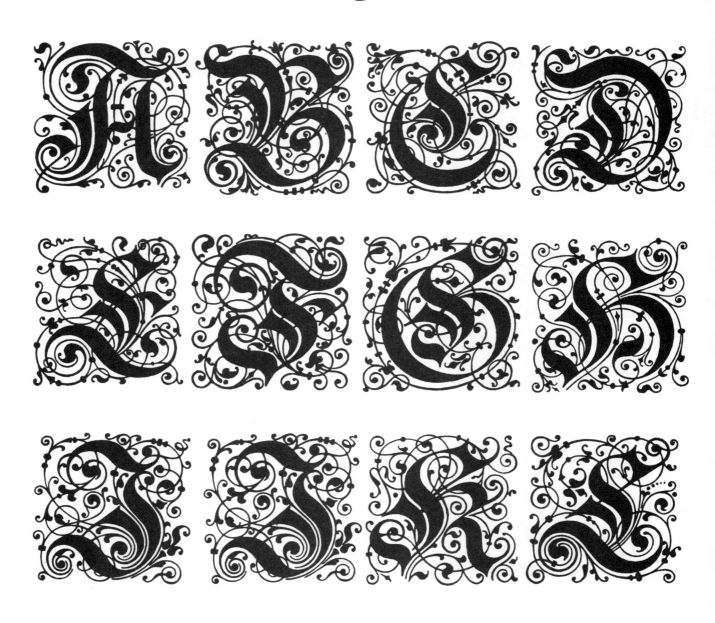

Hamburg Initials

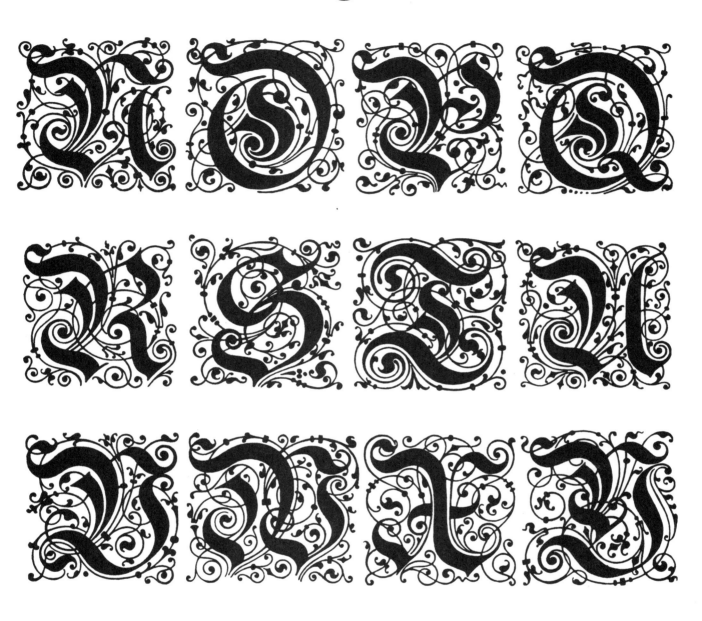

33

Hampshire Initials

Hampshire Initials

Hansa Gothic

ABCDEF
GHIJKLM
abcdefghij
klm
12345

Hansa Gothic

NOPNRS

TUVWXYZ

nopqrstuvw

xyz

67890

Harrowgate

A B C D E F
G H I J K
L M N
a b c d e f g h i
k l m n o p q r

38

Harrowgate

O P Q R S T
U V W X
Y Z

s t u v w x y z

1 2 3 4 5 6 7 8 9 0

Huntington Initials

Huntington Initials

 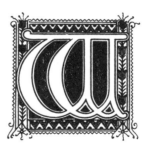 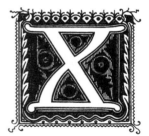

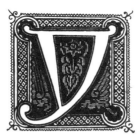 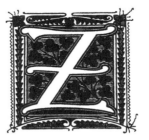

Kaiser Gothic

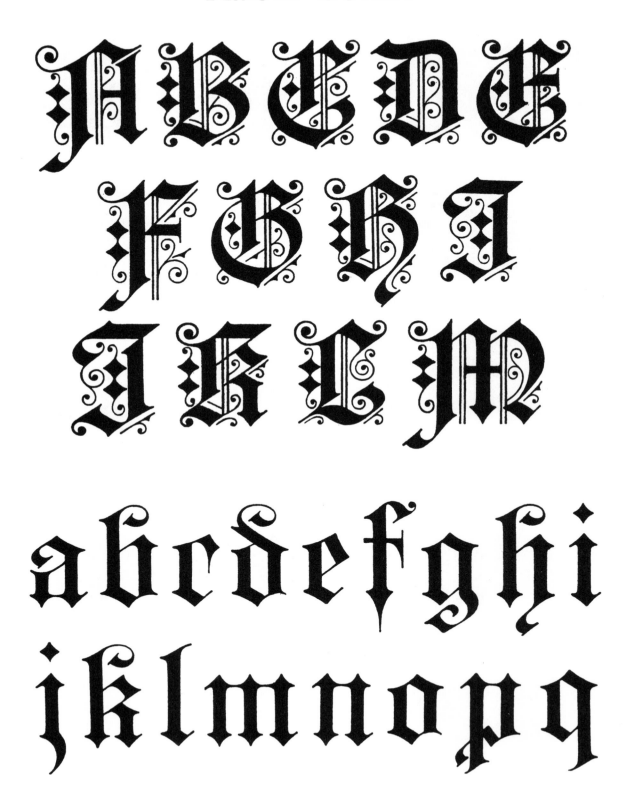

Kaiser Gothic

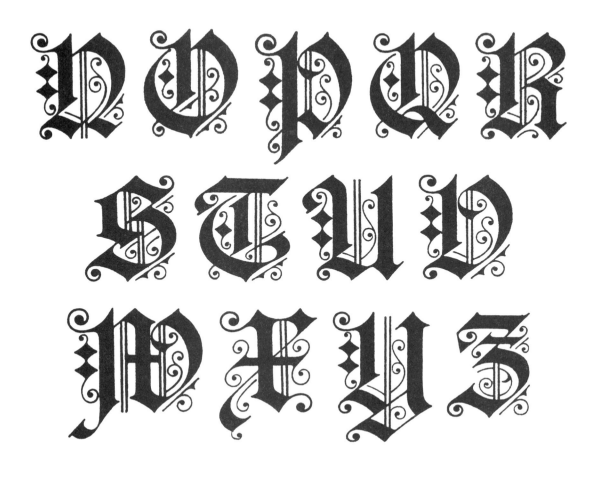

r s t u v w x y z

1 2 3 4 5 6 7 8 9 0

King's Cross

$$\mathfrak{A}\ \mathfrak{B}\ \mathfrak{C}\ \mathfrak{D}\ \mathfrak{E}$$

$$\mathfrak{F}\ \mathfrak{G}\ \mathfrak{H}\ \mathfrak{I}\ \mathfrak{J}$$

$$\mathfrak{K}\ \mathfrak{L}\ \mathfrak{M}$$

$$\mathfrak{a}\ \mathfrak{b}\ \mathfrak{c}\ \mathfrak{d}\ \mathfrak{e}\ \mathfrak{f}\ \mathfrak{g}$$

$$\mathfrak{h}\ \mathfrak{i}\ \mathfrak{j}\ \mathfrak{k}\ \mathfrak{l}\ \mathfrak{m}\ \mathfrak{n}$$

King's Cross

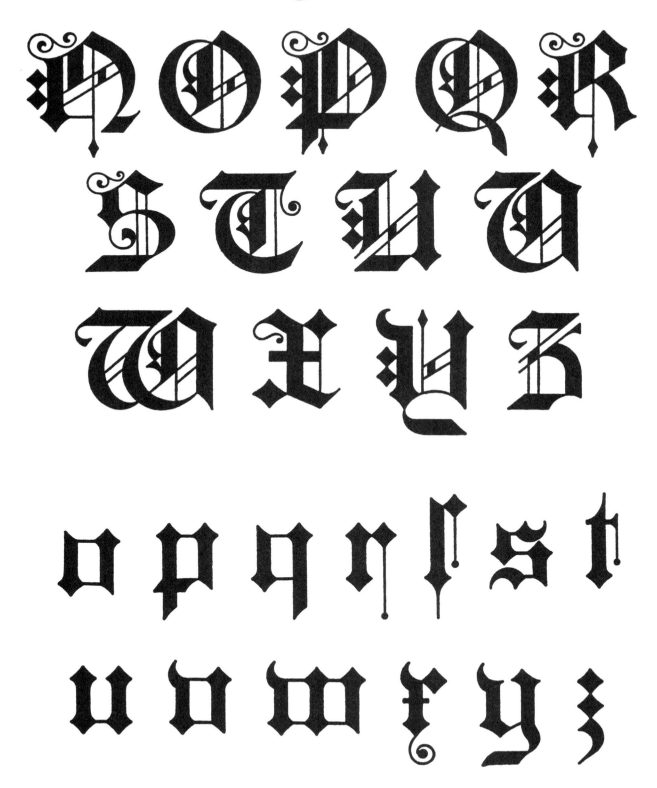

Konigsburg

A B C D E
F G H I J
K L M

a b c d e f
g h i k l m

Konigsburg

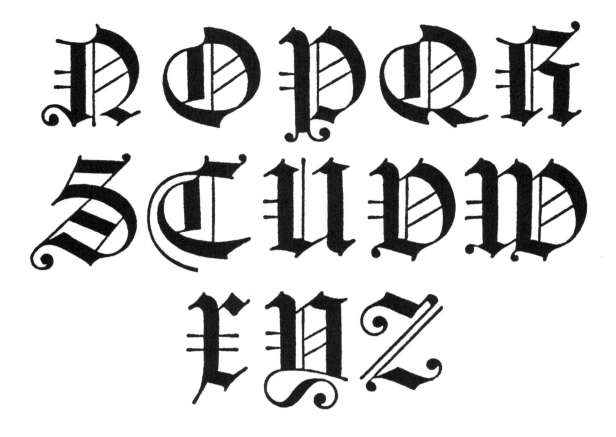

n o p q r s t

u v w x y z

47

Leister

ABCDEFG

HIJKLM

abcdefghi

jklm

12345

Leister

NOPQRST

UVWXYZ

nopqrstuv

wxyz

67890

Leipzig Initials

Leipzig Initials

Lowenbrau

A B C D E

F G H I J

K L M

a b c d e f g h

i j k l m

Lowenbrau

NOPQR
STUVW
XYZ

nopqrſstu
vwxyz

53

Malvern

A B C D E
F G H I J
K L M

a b c d e f g h
i j k l m

Malvern

NOPQR
STUVW
XYZ

nopqrstu
vwxyz

Medici Text

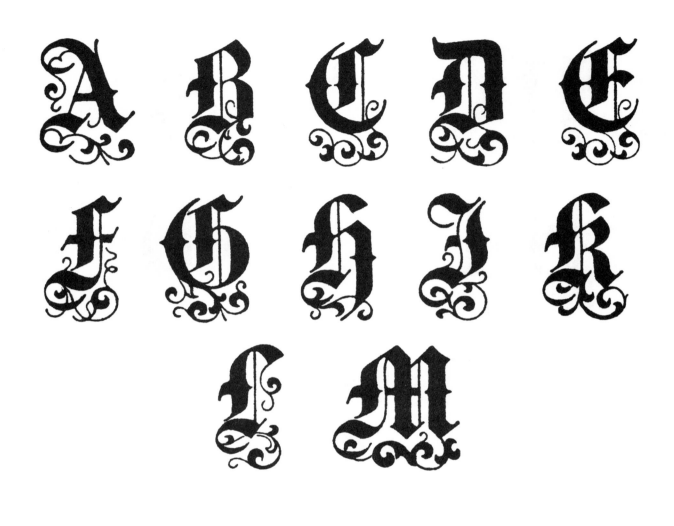

a b c d e f g h
i k l m n

Medici Text

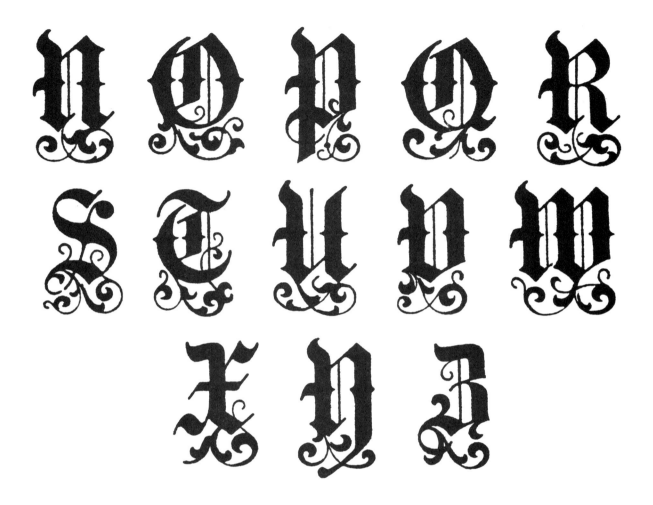

o p q r ſ s t u

v w x y z

Middlesex

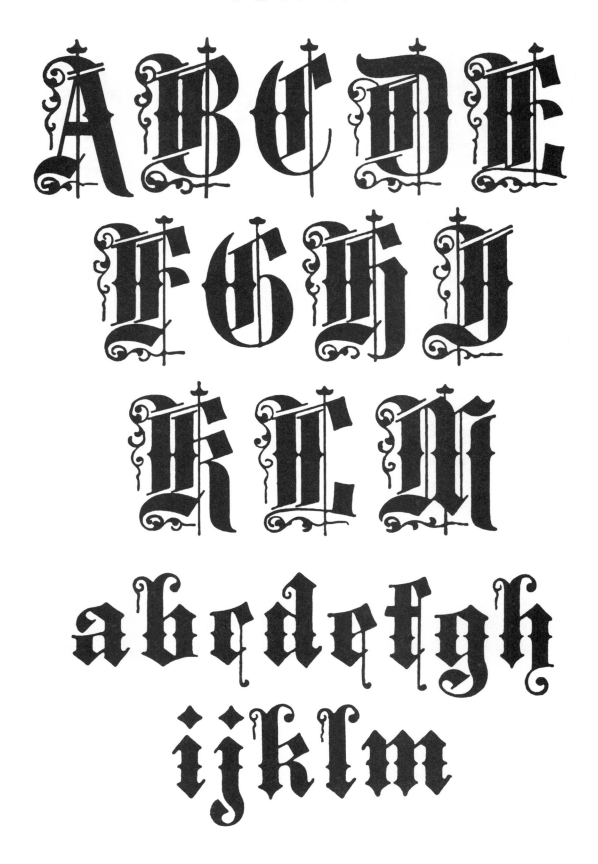

Middlesex

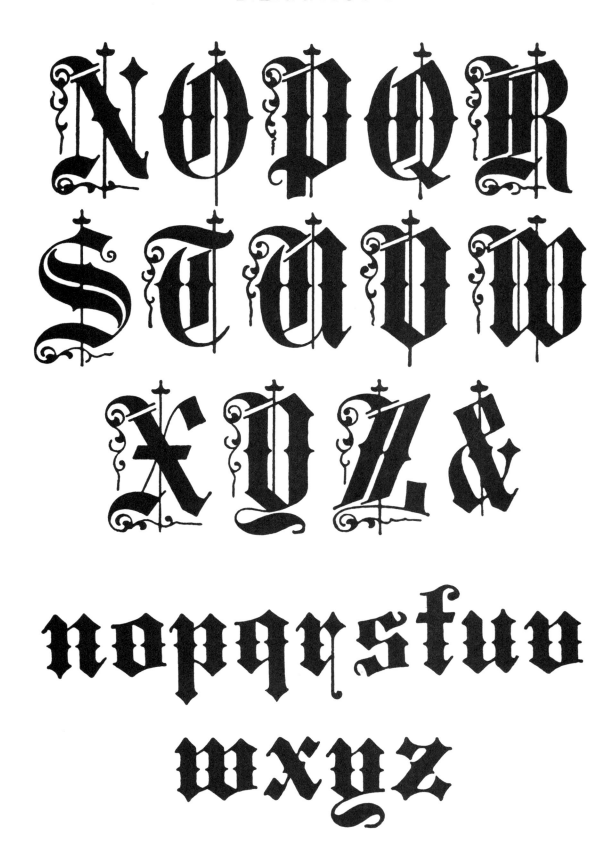

Monument

ABCDEFG
HIJKLM
abcdefgh
ijklm
12345

Monument

NOPQRST
UVWXYZ

nopqrstu
vwxyz

67890

Nottingham

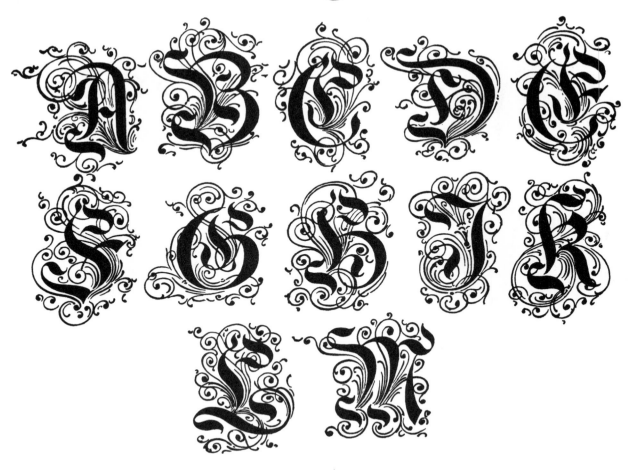

aabbcddeef

gghïjklmmnn

Nottingham

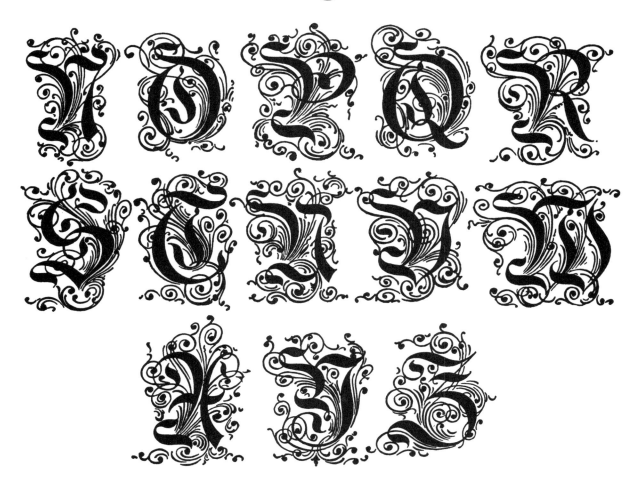

oppqqrss

tuuvwxgyz

Potsdam Initials

Potsdam Initials

Progressive Text

A B C D E

F G H I J

K L M

abcdefghij

klm

12345

Progressive Text

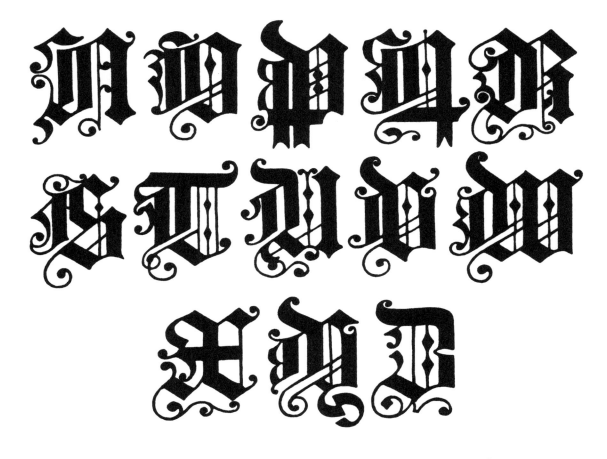

nopqrstuvw

xyz

67890

Regal Black

A B C D

E F G H I

J K L M

a b c d e f g h i j

k l m n

Regal Black

N O P Q

R S T U V

W X Y Z

o p q r s t u v

w x y z

Sans Souci

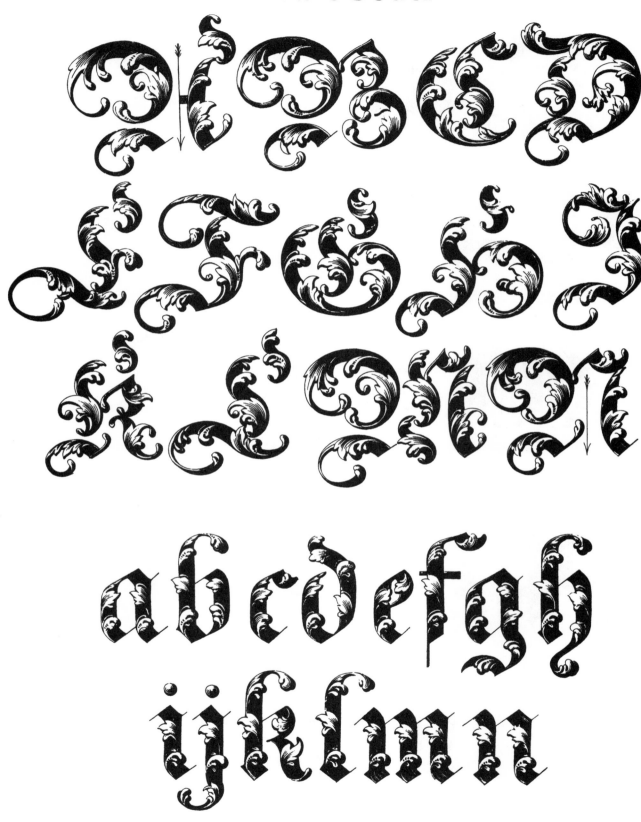

Sans Souci

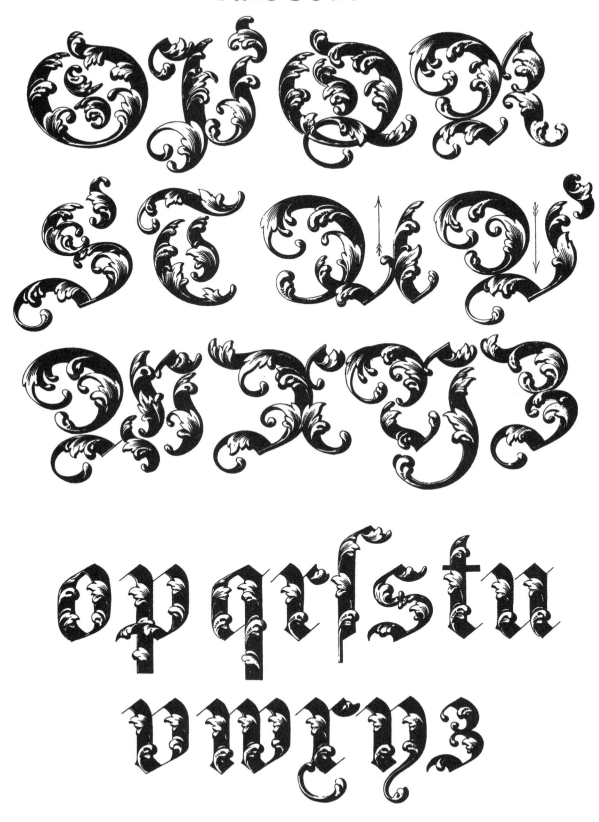

Silver Shadow Black

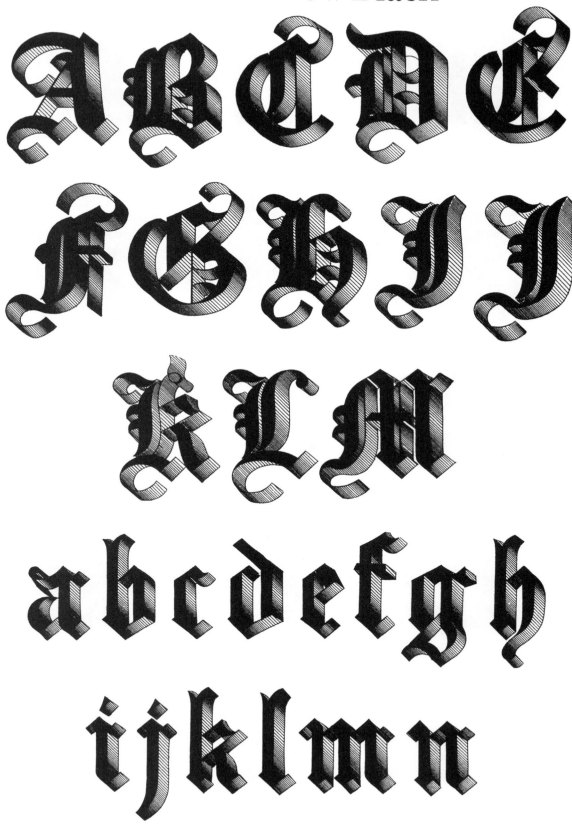

Silver Shadow Black

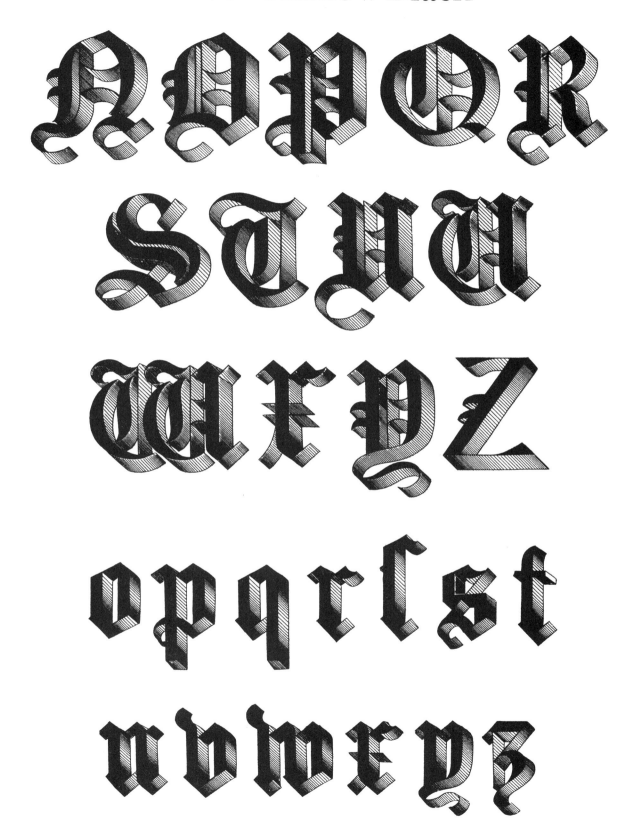

Tory Initials

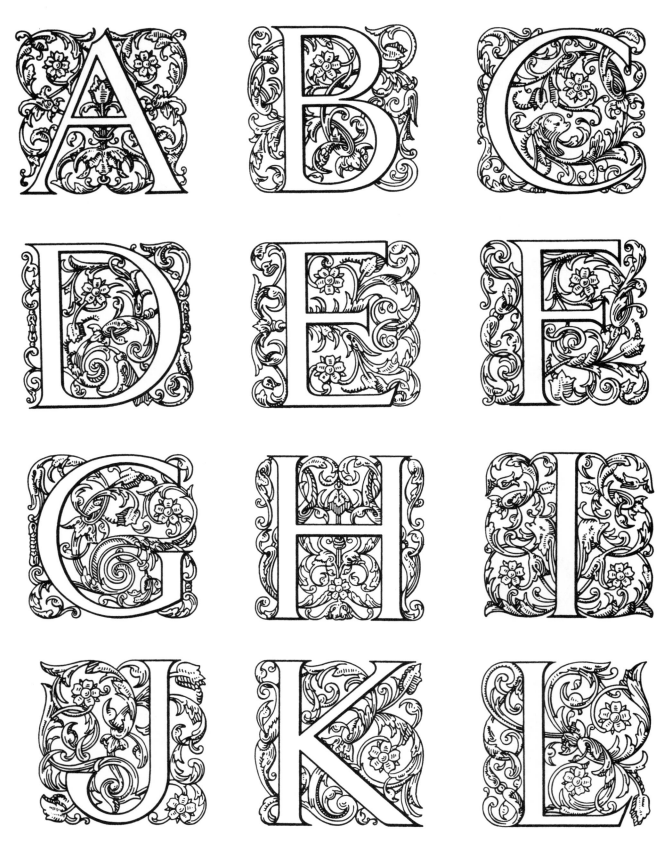

Tory Initials

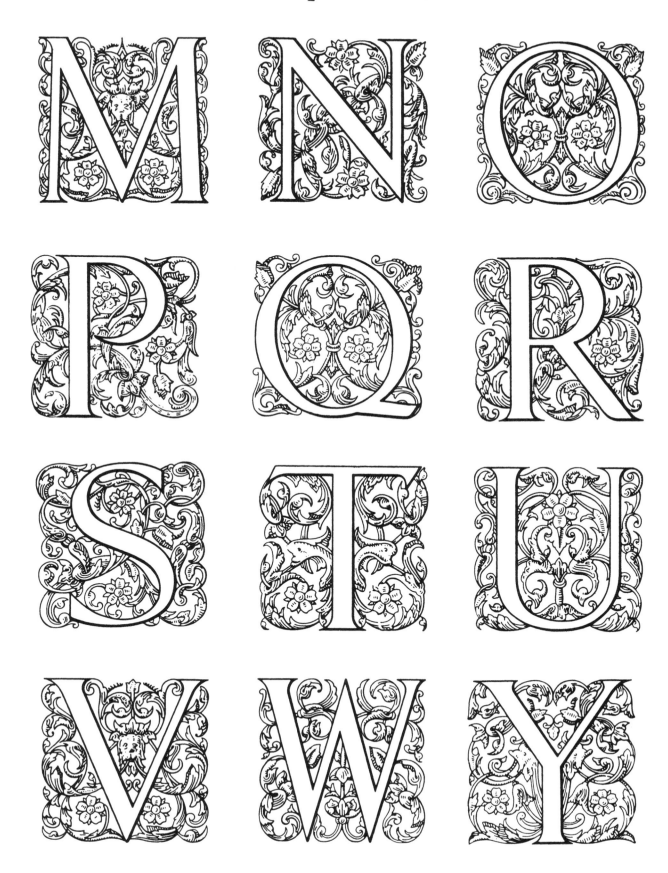

Tudor Text

ABCDE
FGHIJ
KLM

abcdefghi
jklmnopq

Tudor Text

NOPQR
STUV
WXYZ&

rstuvwryz
1234567890

Warwick

A B C D E

F G H I J

K L M

a b c d e f g h

i j k l m n n

1 2 3 4 5

78

Warwick

N O P Q R
S T U V
W X Y Z

o p q r s t u
v w x y z

6 7 8 9 0

79

Westminster Gothic

A B C D E

F G H I J

K L M

a b c d e f g h i

j k l m n o p q

Westminster Gothic

N O P Q R

S T U V W

X Y Z &

r s ſ t u v w x y z

1 2 3 4 5 6 7 8 9 0

Westmorland Text

ABCDE
FGHIJ
KLM

abcdefghij
klmnopq

Westmorland Text

NOPQR
STUVW
XYZ

rstuvwxyz
1234567890

Wien Text

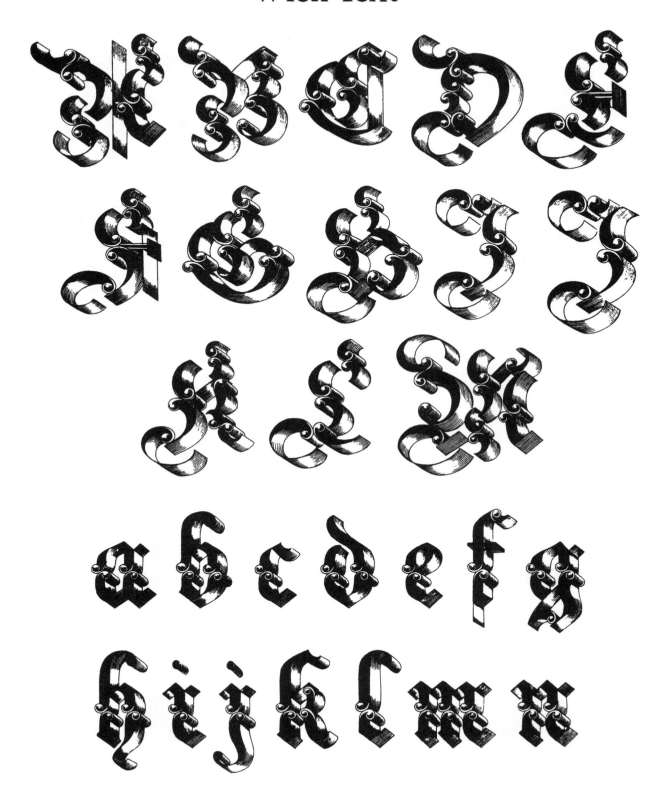

Wien Text

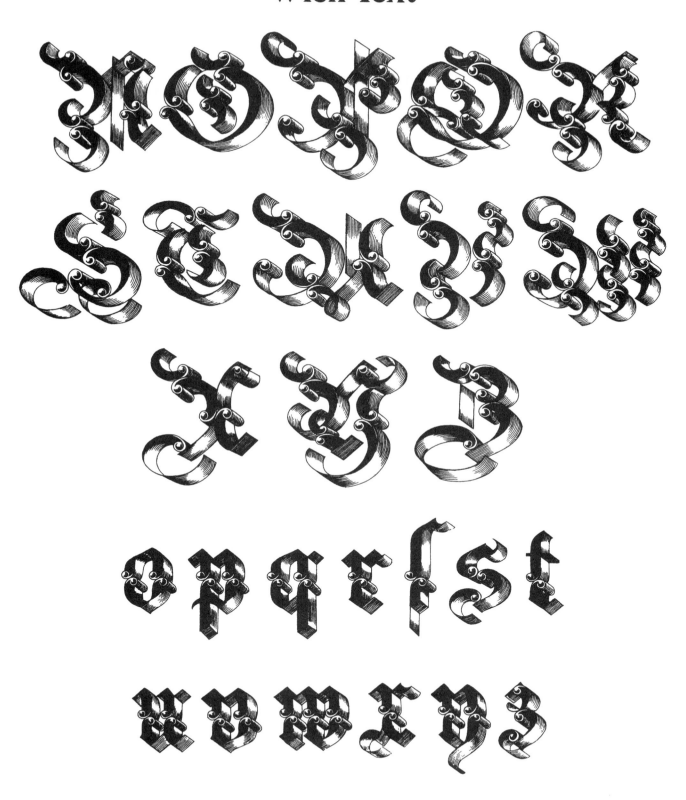

Yonkers

A B C D E
F G H I J
K L M

a b c d e f g h i
j k l m n o p q

Yonkers

NOPQR
STUVW
XYZ

rstuvwxyz
1234567890

Yorkshire Initials

Yorkshire Initials

Zeus Initials

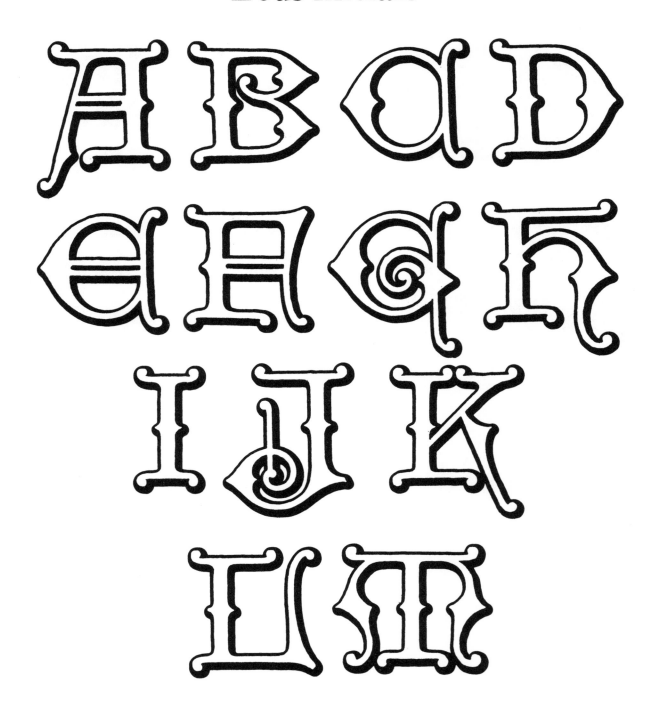

Zeus Initials

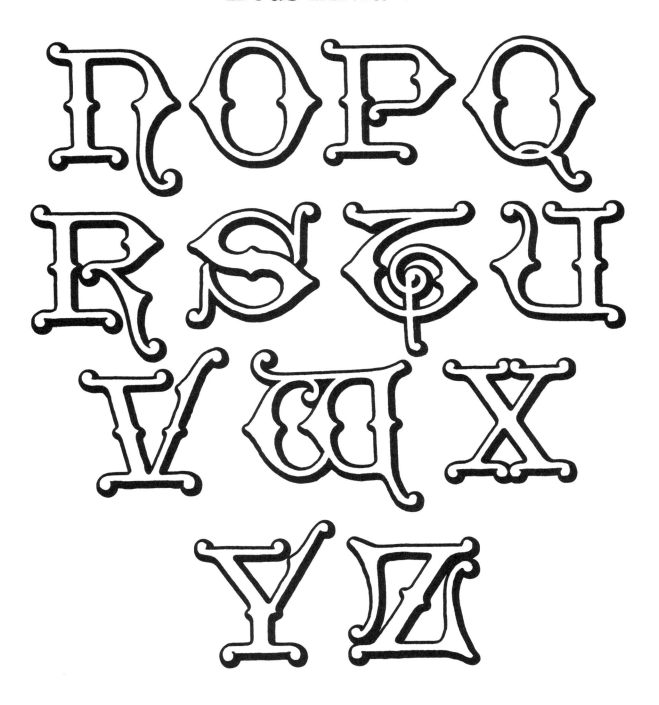

Buckingham Initials

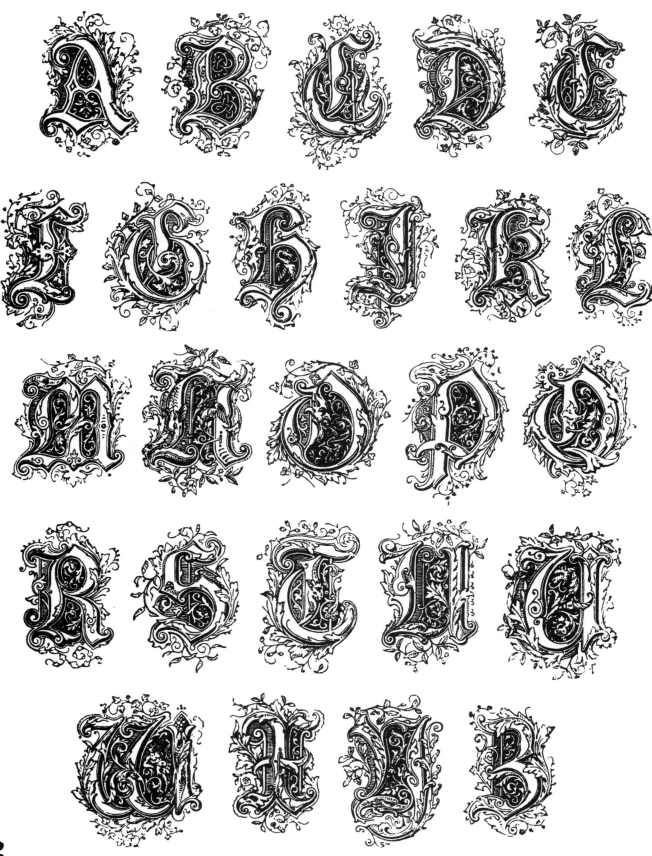

Cheshire Initials

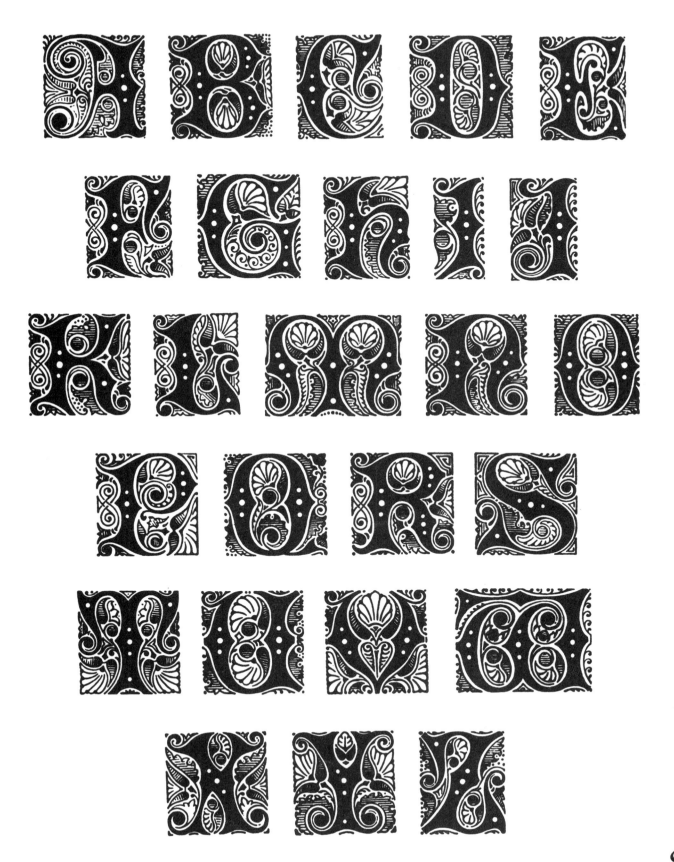

Durbin Initials

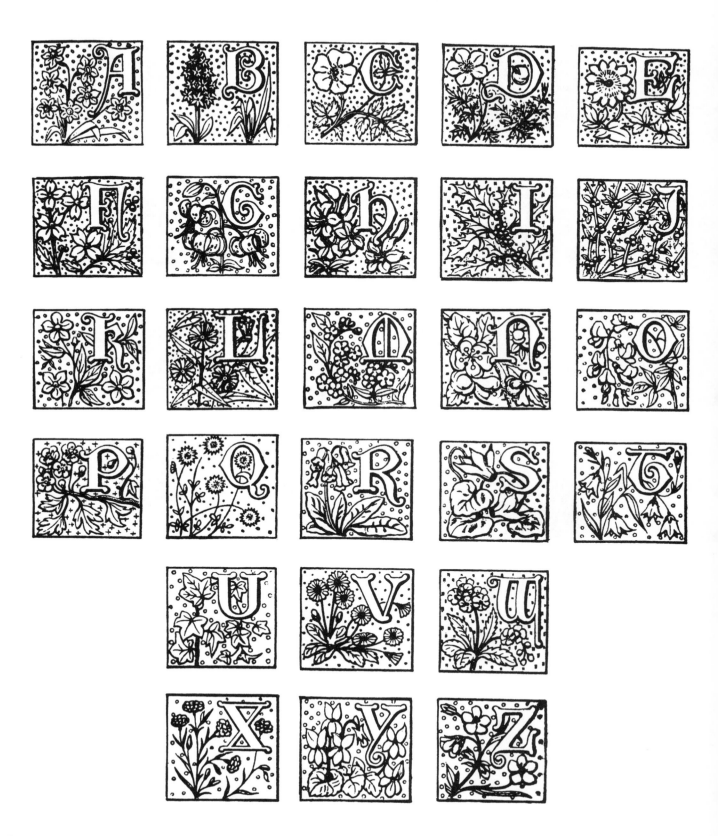

Frankfort Initials

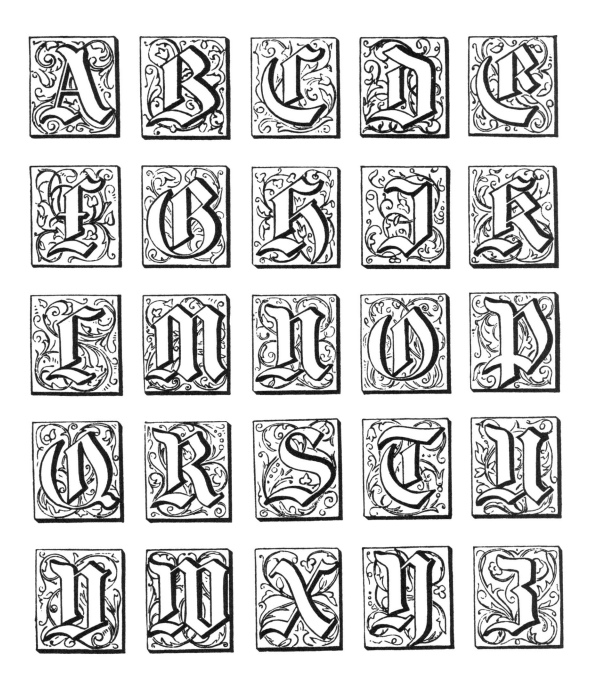

Kupfer Initials

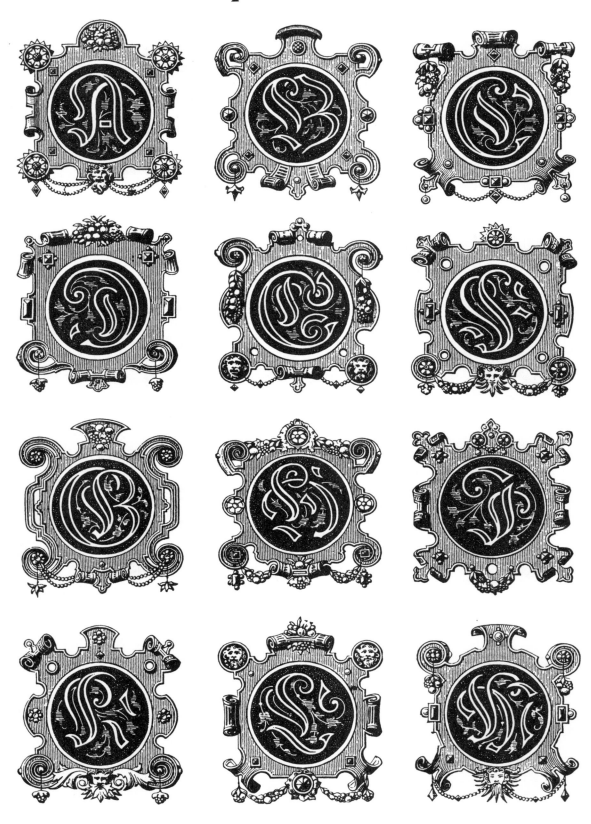

Kupfer Initials

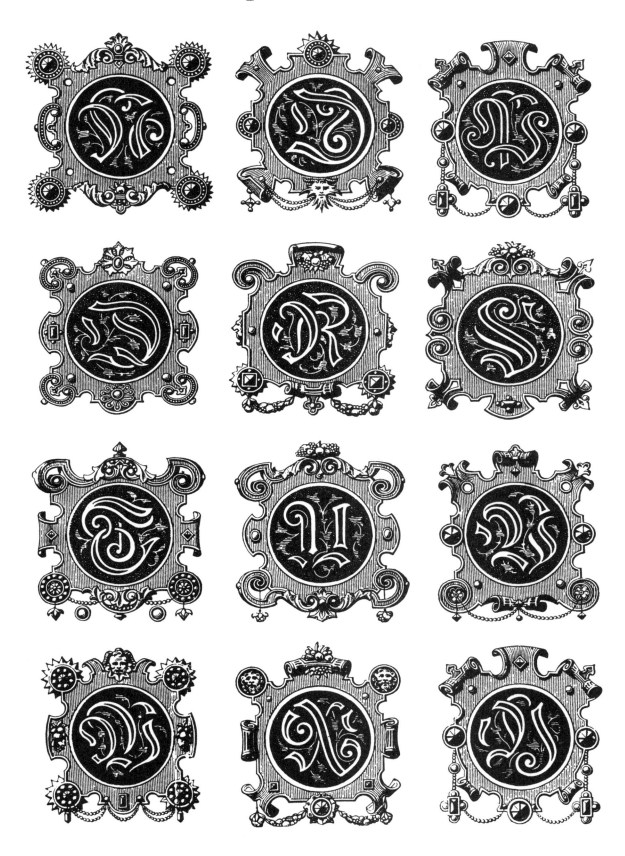

Otto Hupp Initials

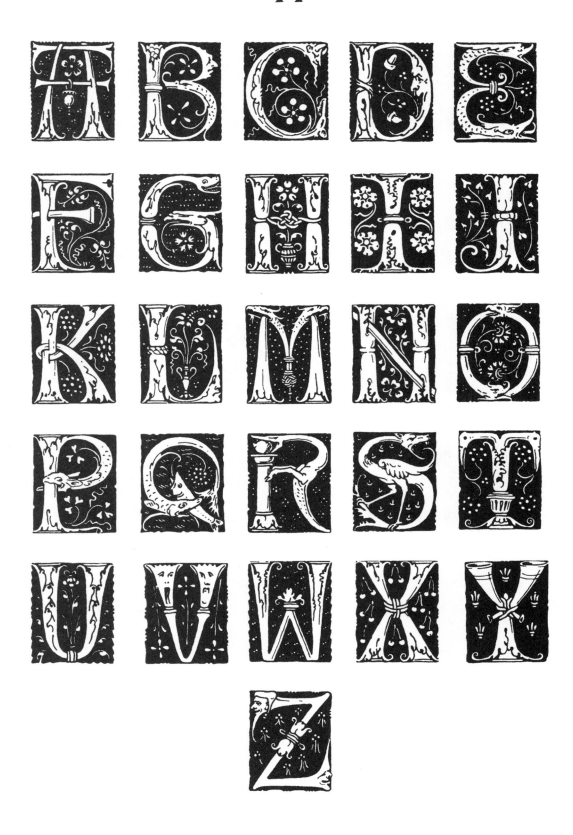

Stuttgart Initials

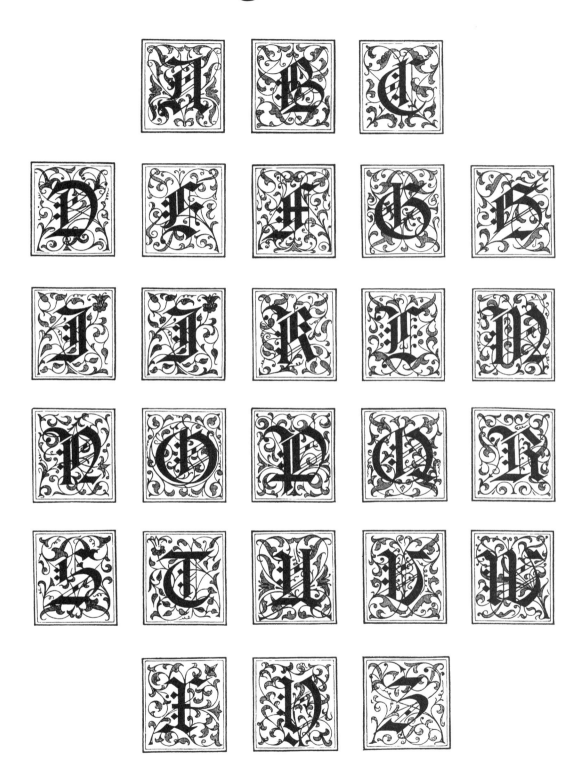

Brussels Initials

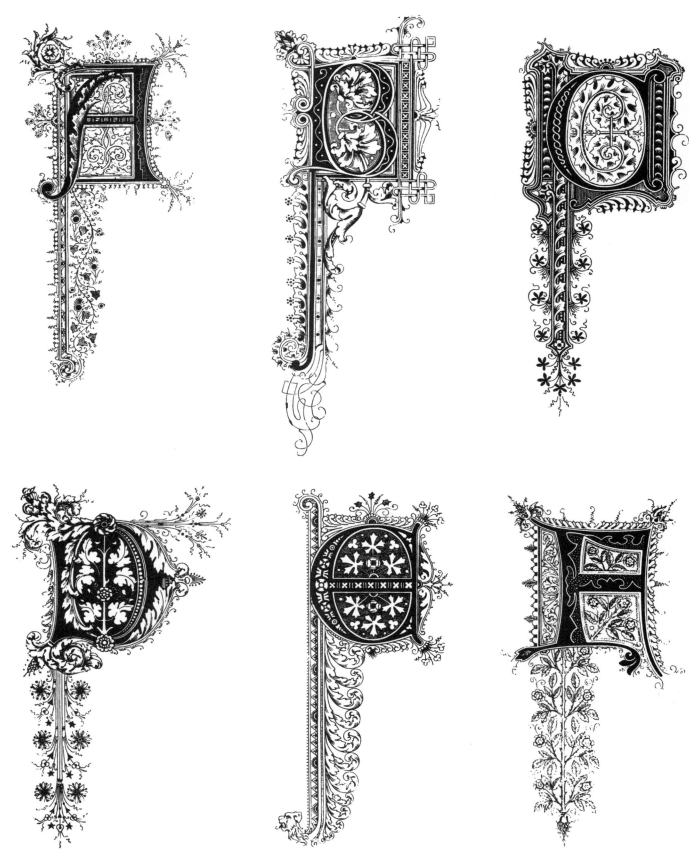

Brussels Initials

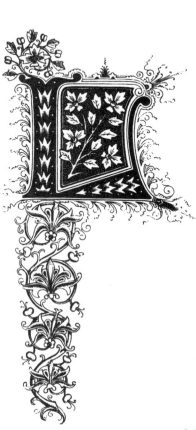

Brussels Initials

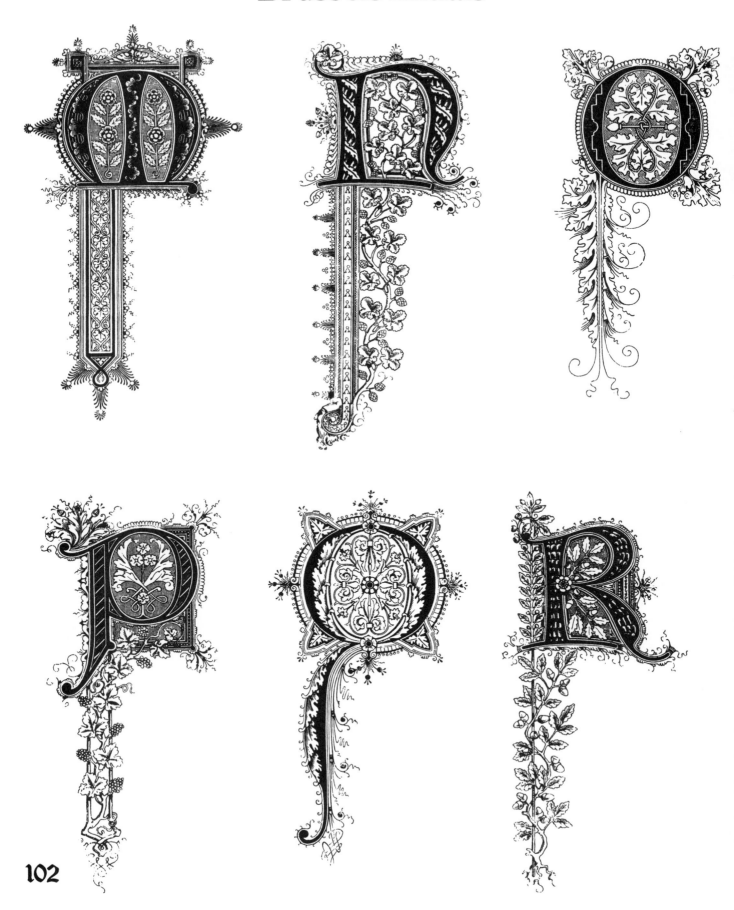

Brussels Initials

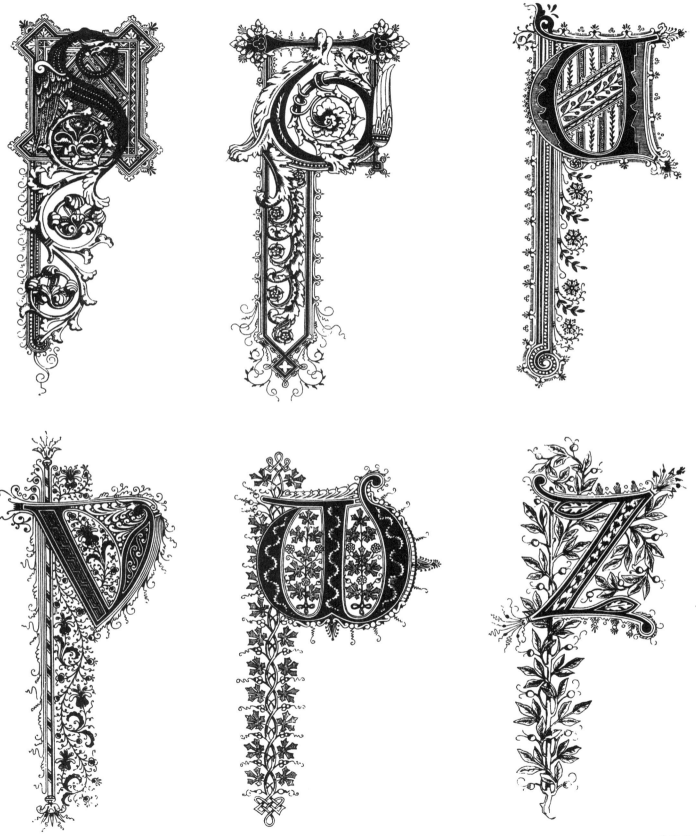